Today meets Yesterday

For Onno & Immi

In 1868, the Chinese emperor sent an envoy by the name of Zhi Gang (志刚) to America and then to Europe to report back on industrialization. Impressed, the scholar told of technological progress and modern production processes, but also of the loss of human values, the pure pursuit of material wealth, and the disappearance of reason. Zhi Gang, like other envoys, feared an excessive use of resources and machines, which replace people more and more and push them out of the focus of creative work. Rather than concentrating on real needs everything was about profit. This way of life went against the traditional Chinese concept of existing in lasting harmony with nature and the heavens.

On the topic of change, opinions have always differed widely. While some delight in progress and the innovations it brings, other mourn after tradition and the good old days. Technological developments obviously bring us many positive advantages, particularly where everyday comforts are concerned. They have come to define lifestyles in big cities all over the world and are now considered status symbols.

Nowadays, we hardly have to move anymore and manage our entire lives with one tiny device. We have come—at least technologically speaking—farther within the past 200 years, than in the millennia before. We have friends around the globe; people from all over the world "like" our posts and can take part in our daily lives. We love transparency and value a hierarchy-free society. An immeasurable amount of information streams through the internet—it seems endless. Our computers are

onstantly getting faster; human efficiency seems capable of increas-
ng ad infinitum.

What happens in and with us in times like these? How do we handle our
hanging environment? What exactly are the differences between back
hen and today? What are the changes doing to our society? How are our
abits, perceptions, political stances, our values, and lastly, our view of
he world changing? Could it be that, along with the many benefits we
ope to gain from progress and those that have already manifested, some
f the fears held by the Chinese envoy 150 years ago have come true?

hree years ago, I began documenting these changes through my per-
onal experiences and perceptions in pictures. They have been gathered
n this book and will hopefully inspire further conversation and exchange.

Breakfast

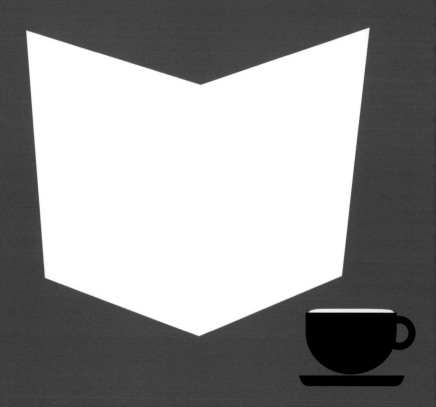

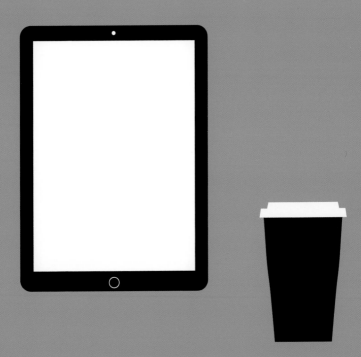

Circle of friends

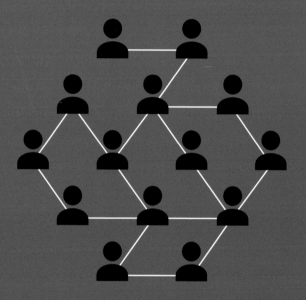

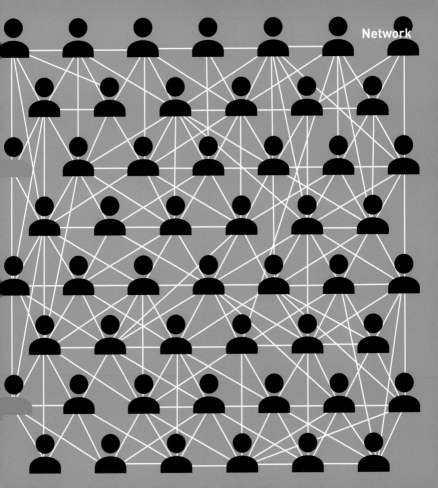
Network

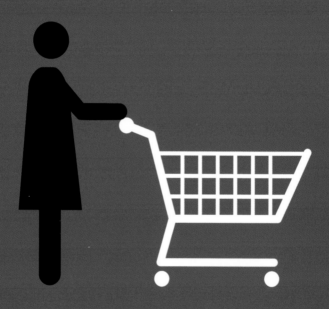

Shopping

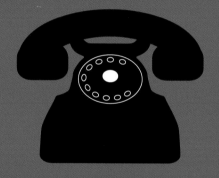

Coffee

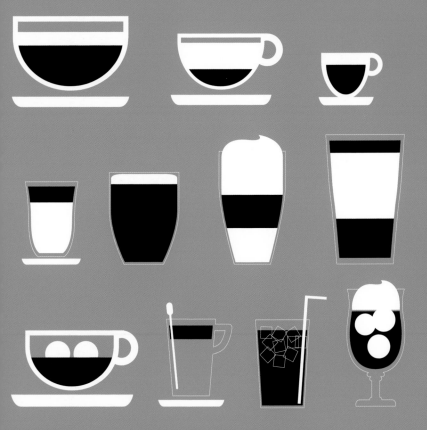

Noise

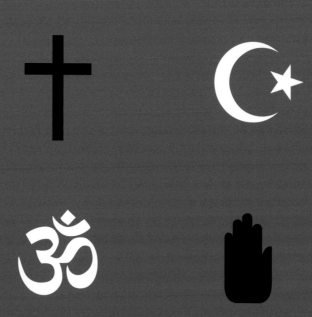

f

 in

Concert

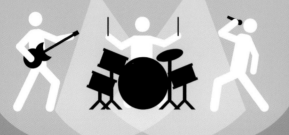

Concert

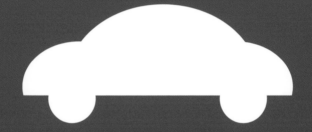

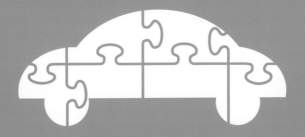

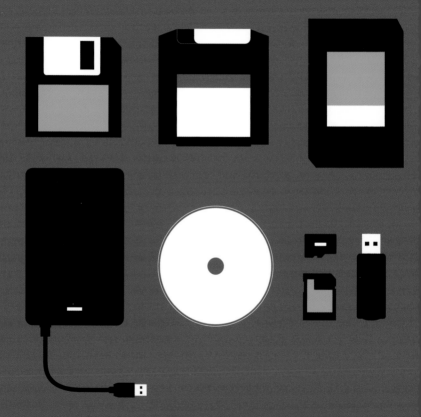

Storage media

Cell phones

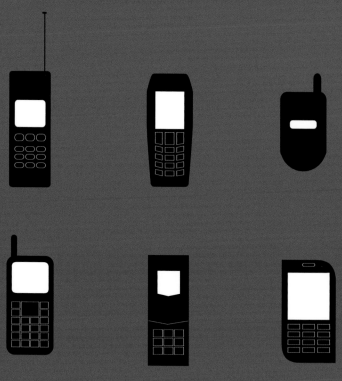

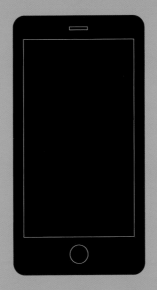

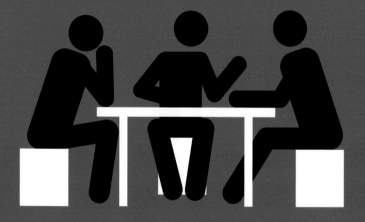

Meeting with friends

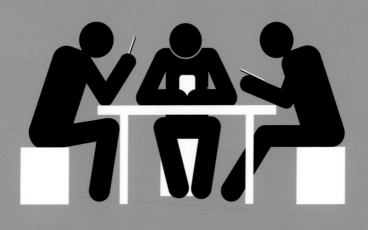

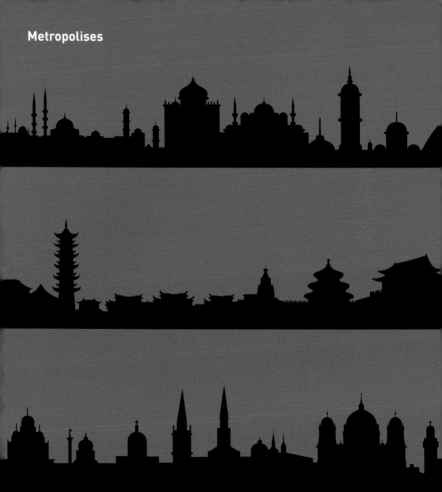

Metropolises

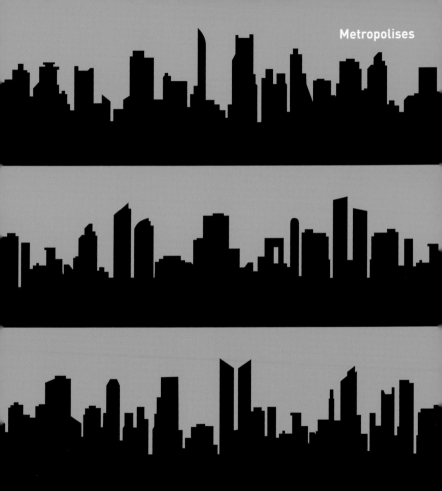

Metropolises

1945

need

buy

toss

today

need

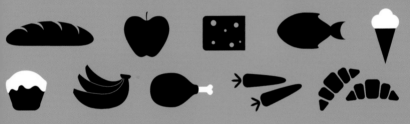

buy

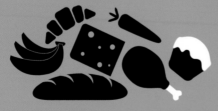

toss

Packaging waste

City – suburbs – country

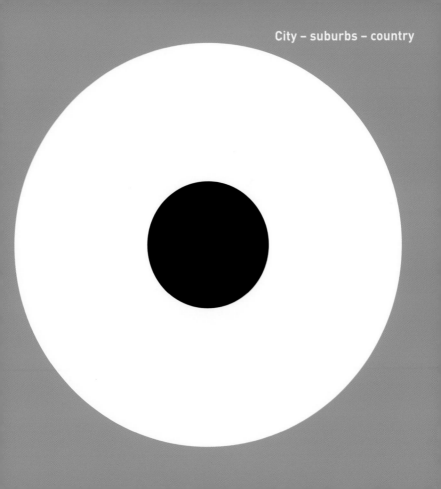

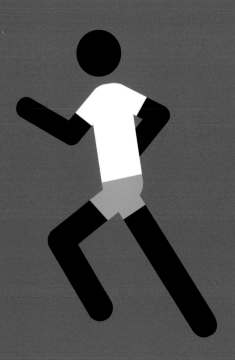

Running

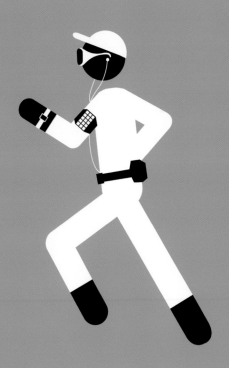

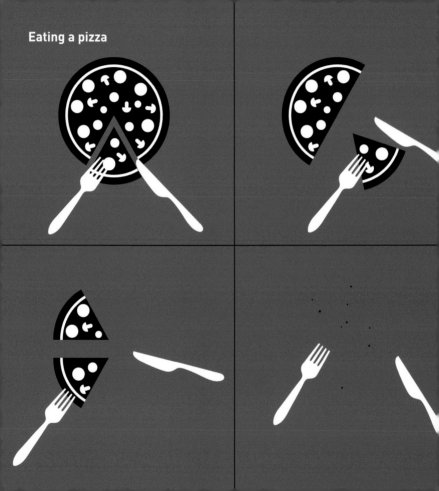

Eating a pizza

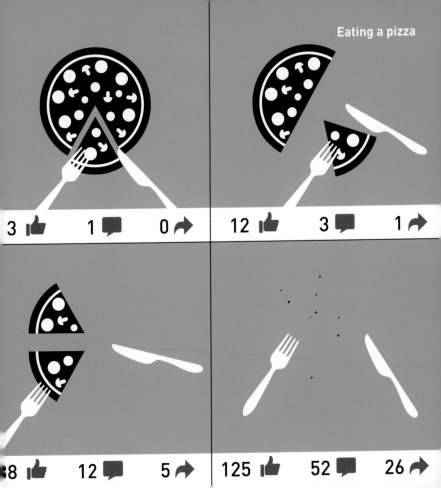

Eating a pizza

3 👍 1 💬 0 ➡

12 👍 3 💬 1 ➡

8 👍 12 💬 5 ➡

125 👍 52 💬 26 ➡

1965

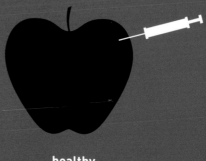

healthy

unhealthy

healthy

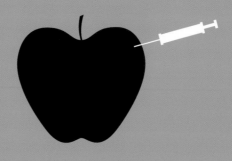

unhealthy

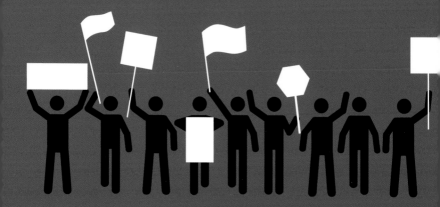

Demonstration

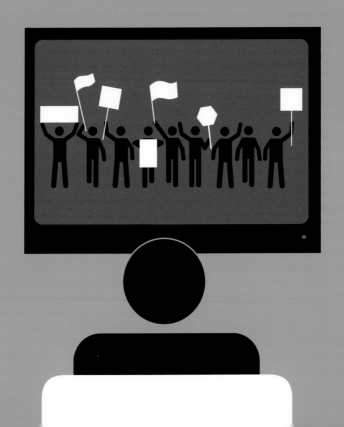

Playing

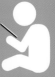

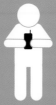

Shortsightedness among children

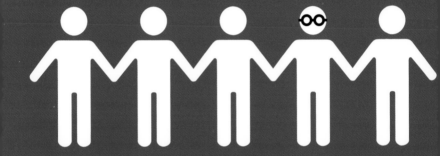

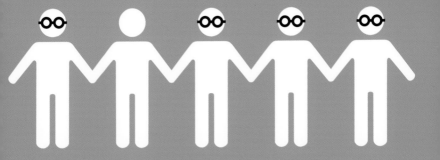

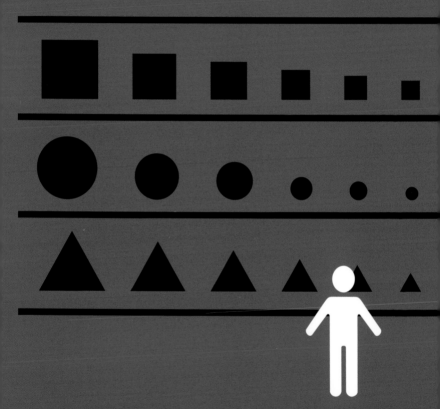

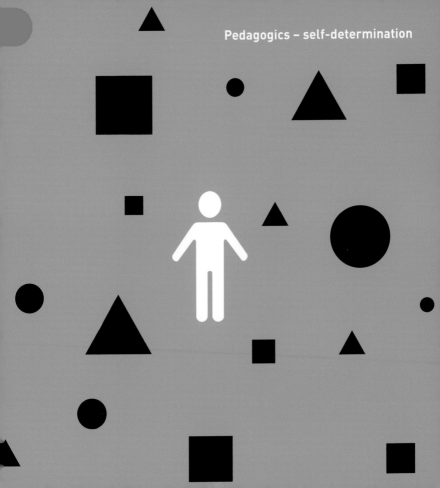

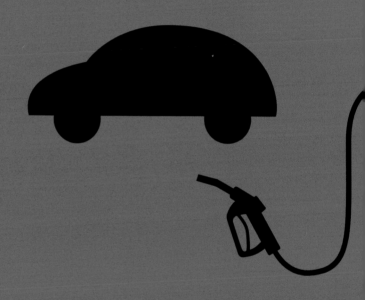

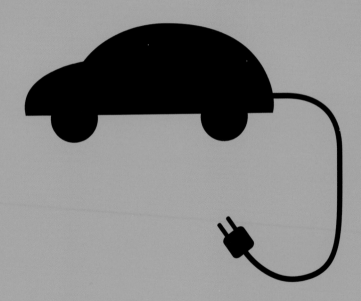

Cucumbers

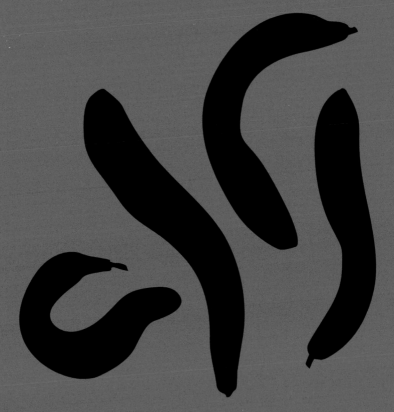

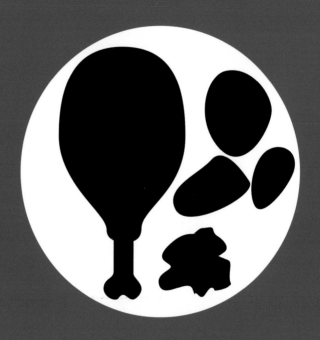

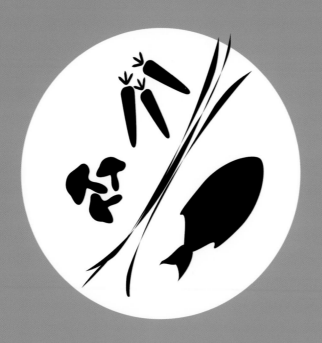

Product testing

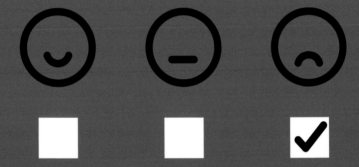

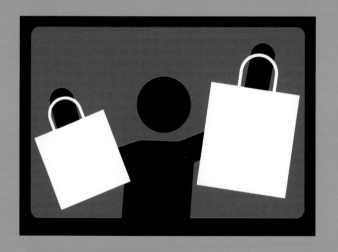

Artisanry

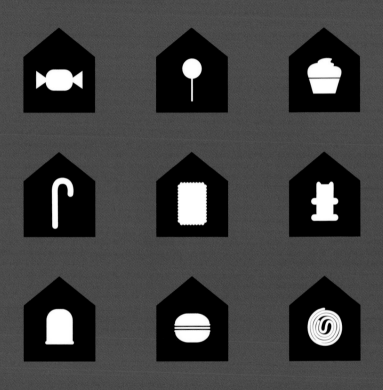

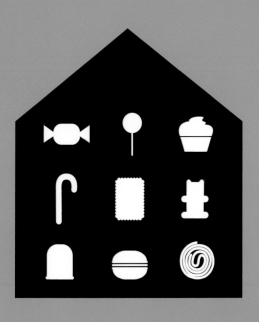

Concentration

Individual

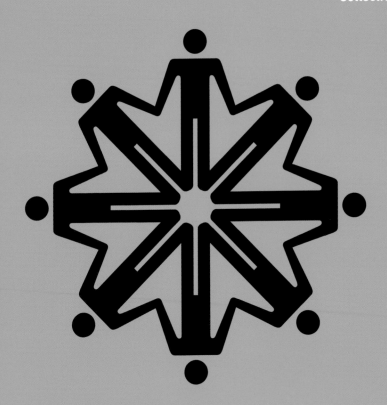

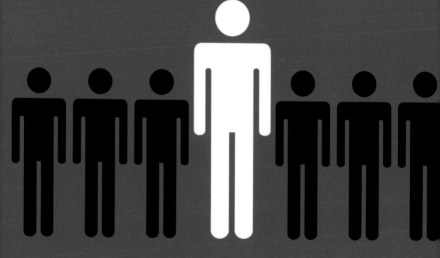

Boss

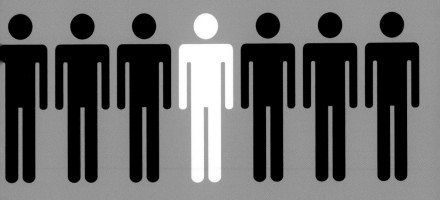

Formation of worldview

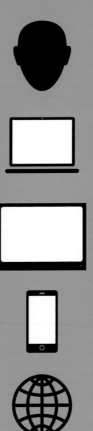

Leisure – work

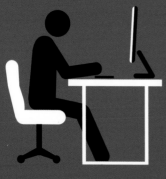

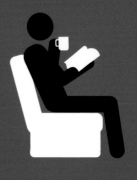

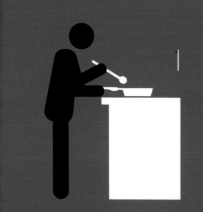

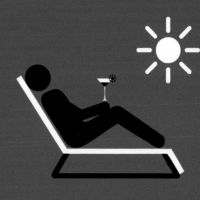

Work – leisure

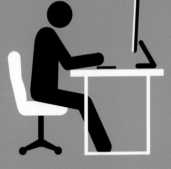

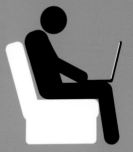

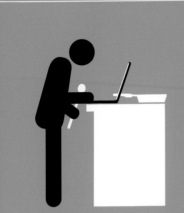

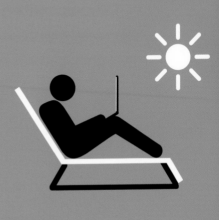

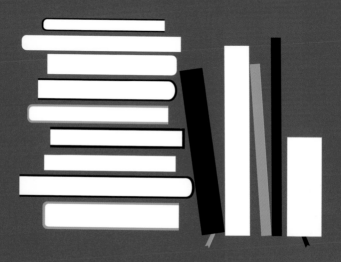

Knowledge

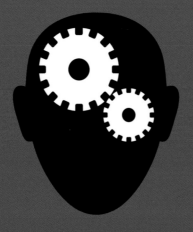

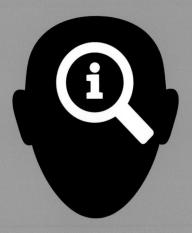

My idea

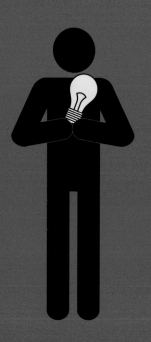

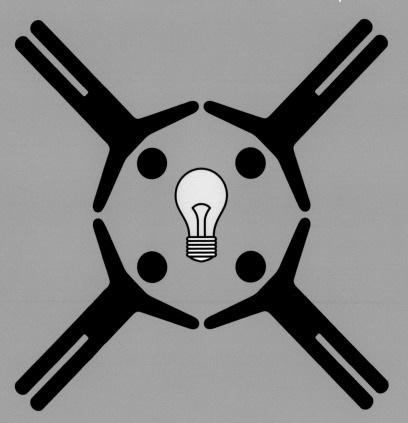

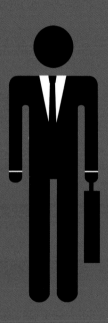

Bank loan

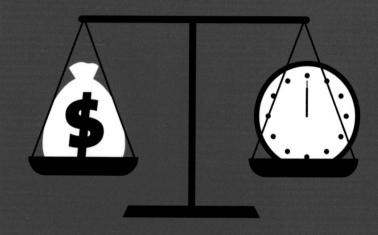

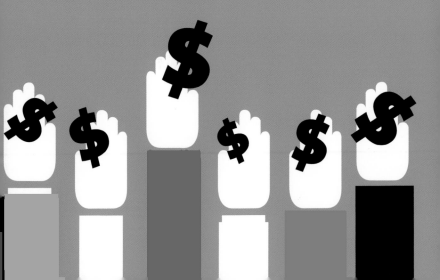

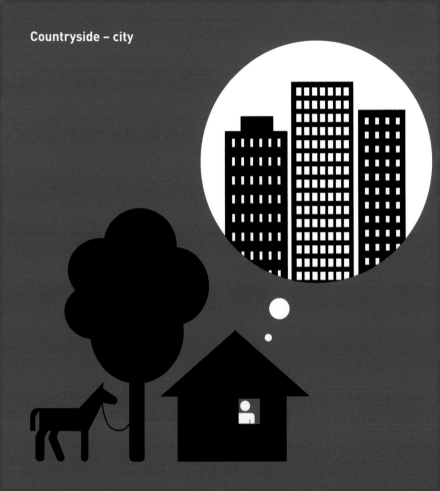

Countryside – city

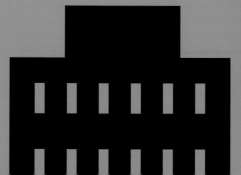
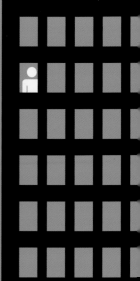
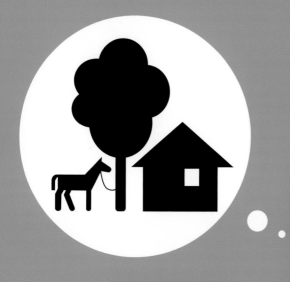

City – countryside

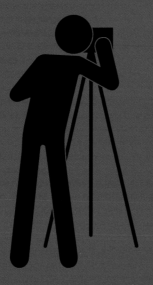

Photo

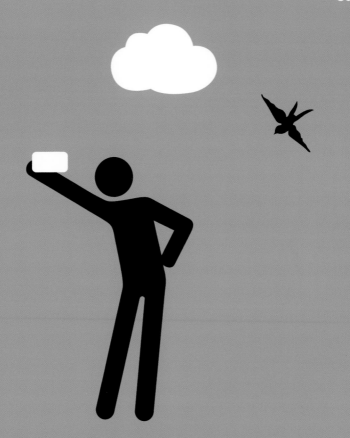

Bullying

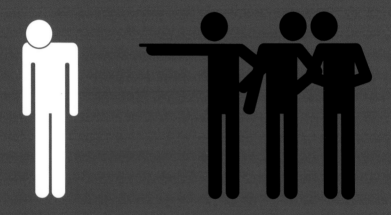

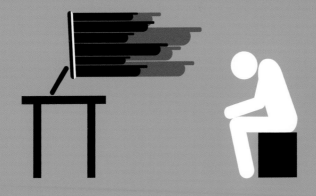

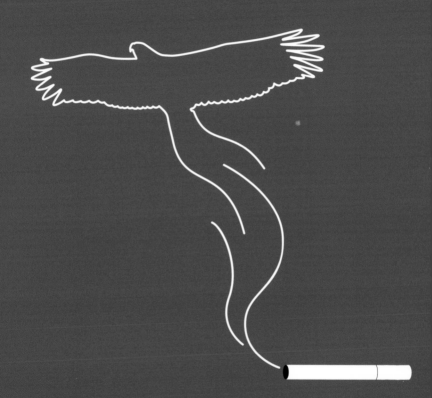

Feeling alive

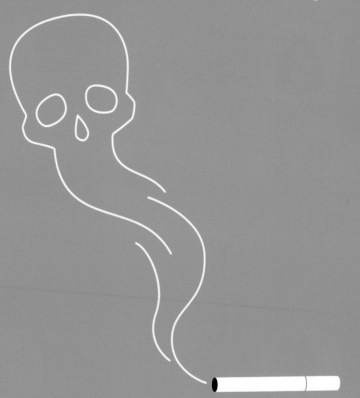

Fur

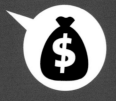

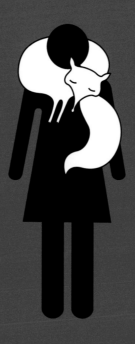

Fur

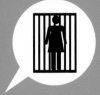
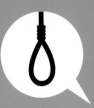

Dolly

Military intervention

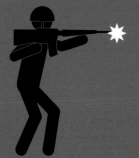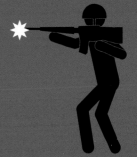

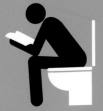

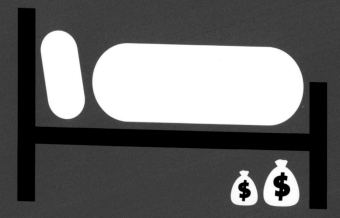

Tax evasion

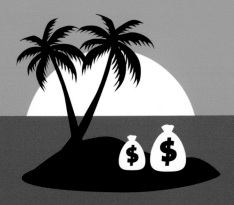

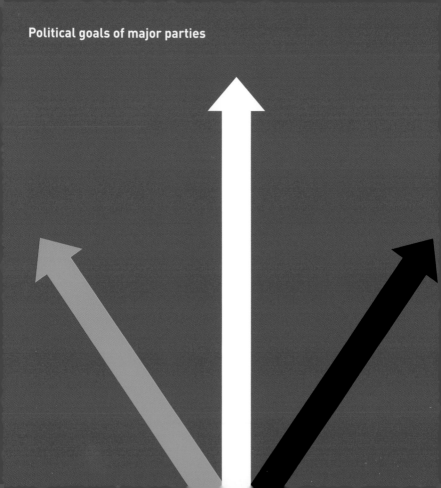

Political goals of major parties

Political goals of major parties

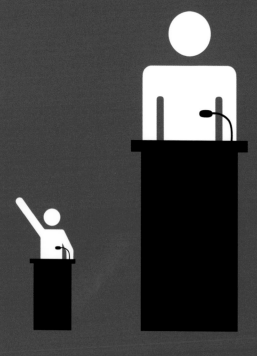

Center ground

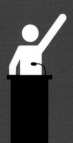

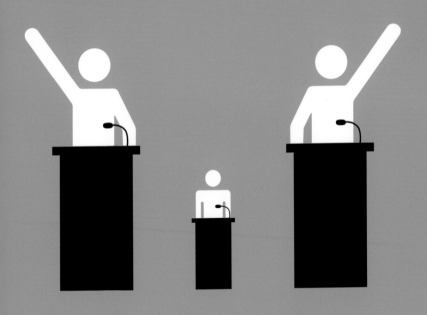

Difference rich – poor

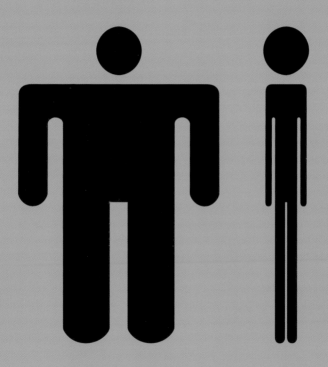

Oceans

Oceans

Chernobyl 1986

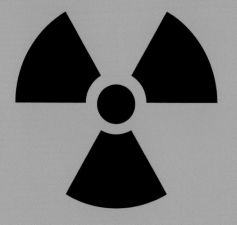

Fukushima 2011

The Arctic

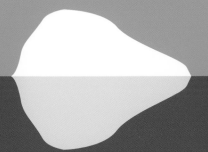

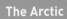

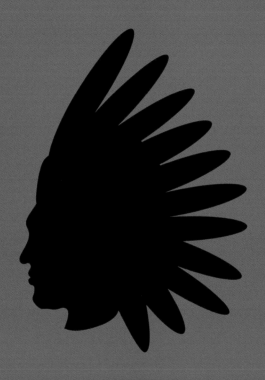

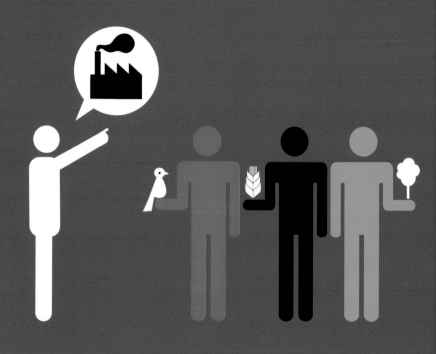

Industrialized countries – rest of the world

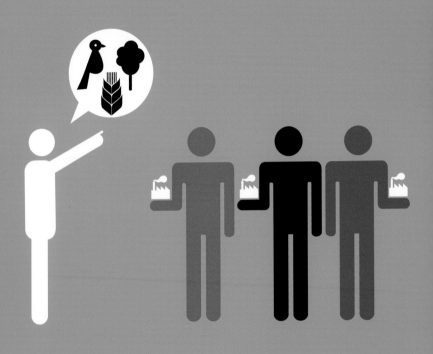

Western perception of the Middle East

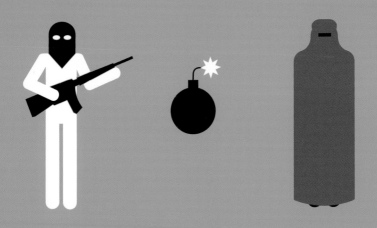

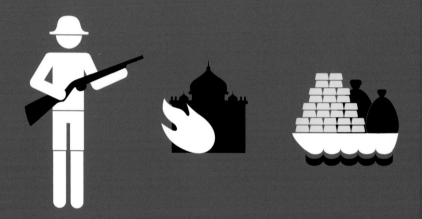

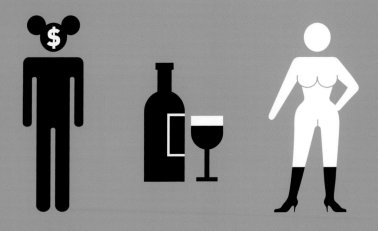

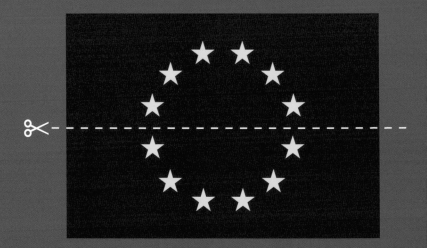

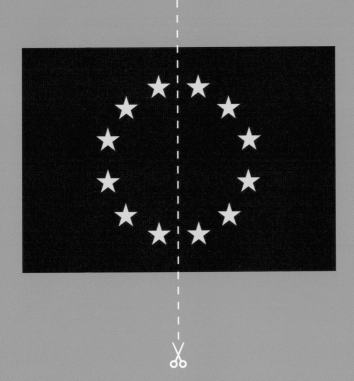

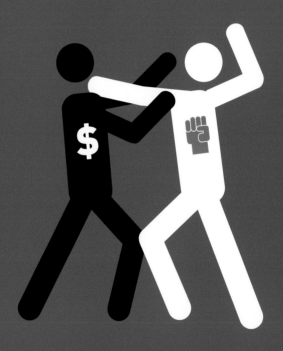

Capitalism – Socialism

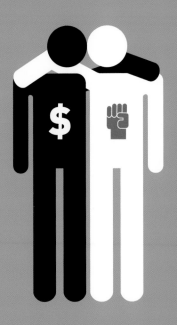

Power

$

Children – adults

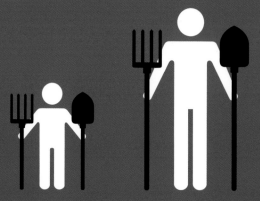

1700

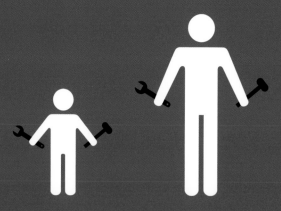

1900

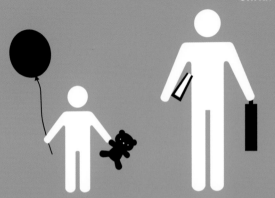

Children – adults

1960

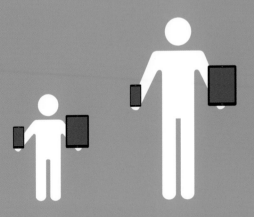

today

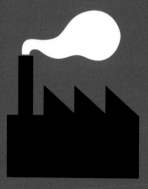

Energy

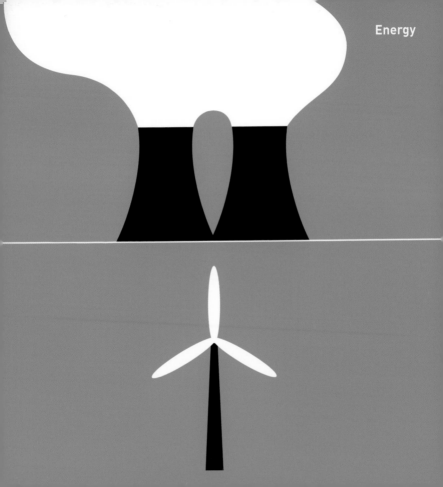

Energy

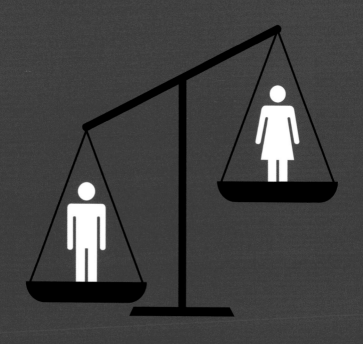

Gender equality

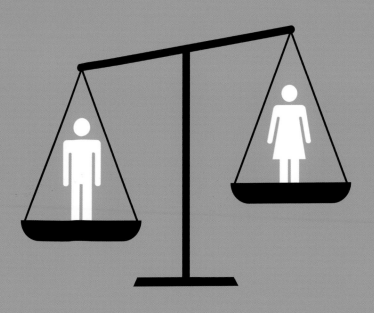

Gender equality

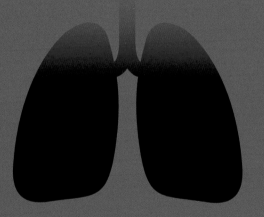

Industrial age – black lung

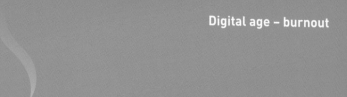

Digital age – burnout

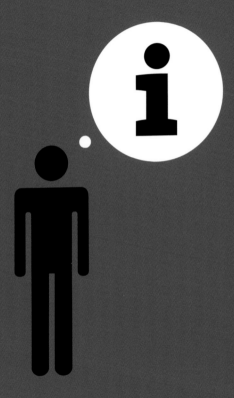

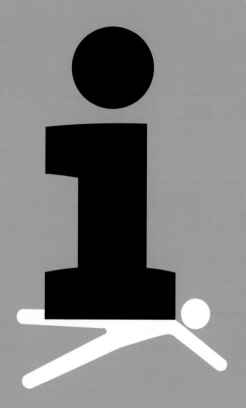

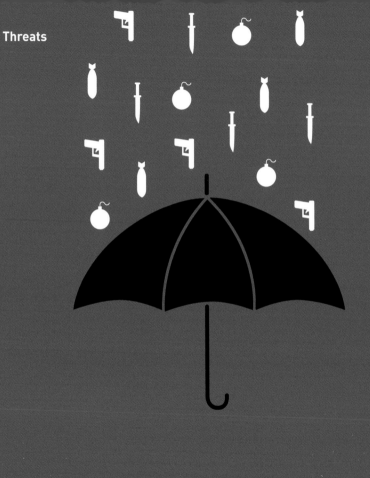
Threats

Past – present – future

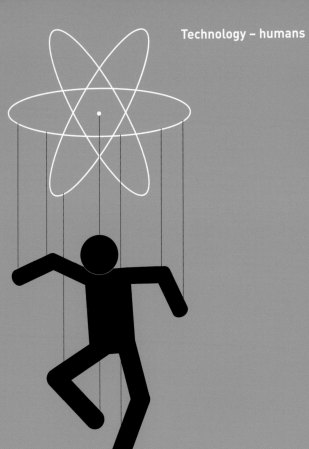

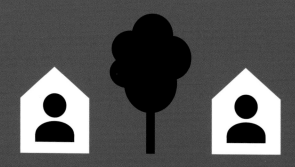

Neighbors

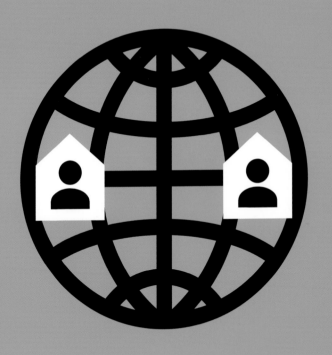

Opposition

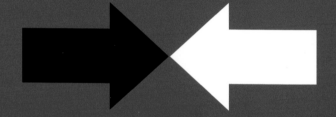

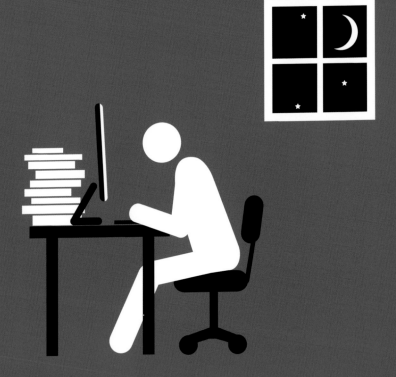

Exploitation

Self-fulfillment

Danger

Privacy

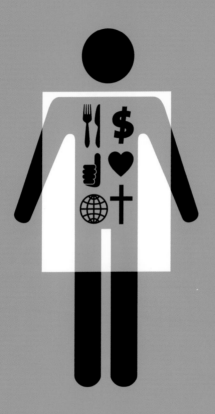

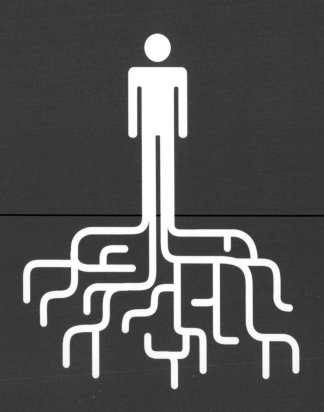

Roots

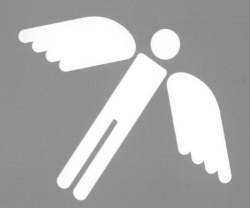

Multicultural

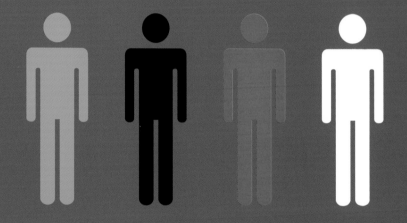

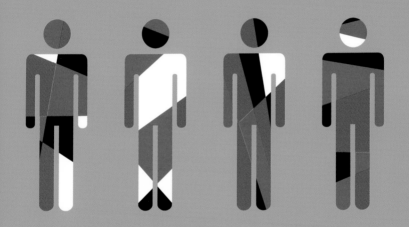

Other books by Yang Liu:

East meets West · 东西相遇
Yang Liu · 刘扬

TASCHEN

"For a generation that increasingly uses emoticons that say much more than words, these books could be the future."
—*Show Daily*, New Delhi

Man meets Woman
Yang Liu

TASCHEN

"...sure to have you laughing at, celebrating and pondering the differences between men and women."
—*Psychologies*, Kent

ang Liu was born in 1976 in Beijing. After studying at the University of rts Berlin (UdK), she worked as a designer in Singapore, London, Berin, and New York. In 2004 she founded her own design studio, which she ontinues to run today. In addition to holding workshops and lectures at nternational conferences, she has taught at numerous universities in ermany and abroad. In 2010 she was appointed a professor at the BTK niversity of Applied Sciences in Berlin. Her works have won numerous rizes in international competitions and can be found in museums and ollections all over the world.

ang Liu lives and works in Berlin.

Today meets yesterday
A book by **Yang Liu**

Idea/Design © Yang Liu

© Copyright of all
artwork and text by
Yang Liu Design
Torstraße 185 · 10115 Berlin
www.yangliudesign.com

Project Management:
Florian Kobler, Berlin
Production: Daniela Asmuth, Cologne
English translation: Hayley Haupt, Ixelles

© 2016 TASCHEN GmbH
Hohenzollernring 53 · 50672 Cologne
www.taschen.com

ISBN 978-3-8365-5405-3

Printed in Italy